Copyright ©2019 The Design Cafe

All rights reserved. Printed in the United States of America. No Part of this book may be used or reproduced in any manner whatsoever without written permission.

ISBN: 9781700919410

To Order Bulk copies for Counseling Groups, Rehabilitation Agencies, and Hospitals email: designcafebooks@gmail.com

This Book is Dedicated to all those in Recovery from life after moments. Sometimes color can be our inspiration to shine, to overcome, to survive, to truly live

-Aija M. Butler

This Book Belongs To:

It does not matter how slowly you go as long as you do not stop.

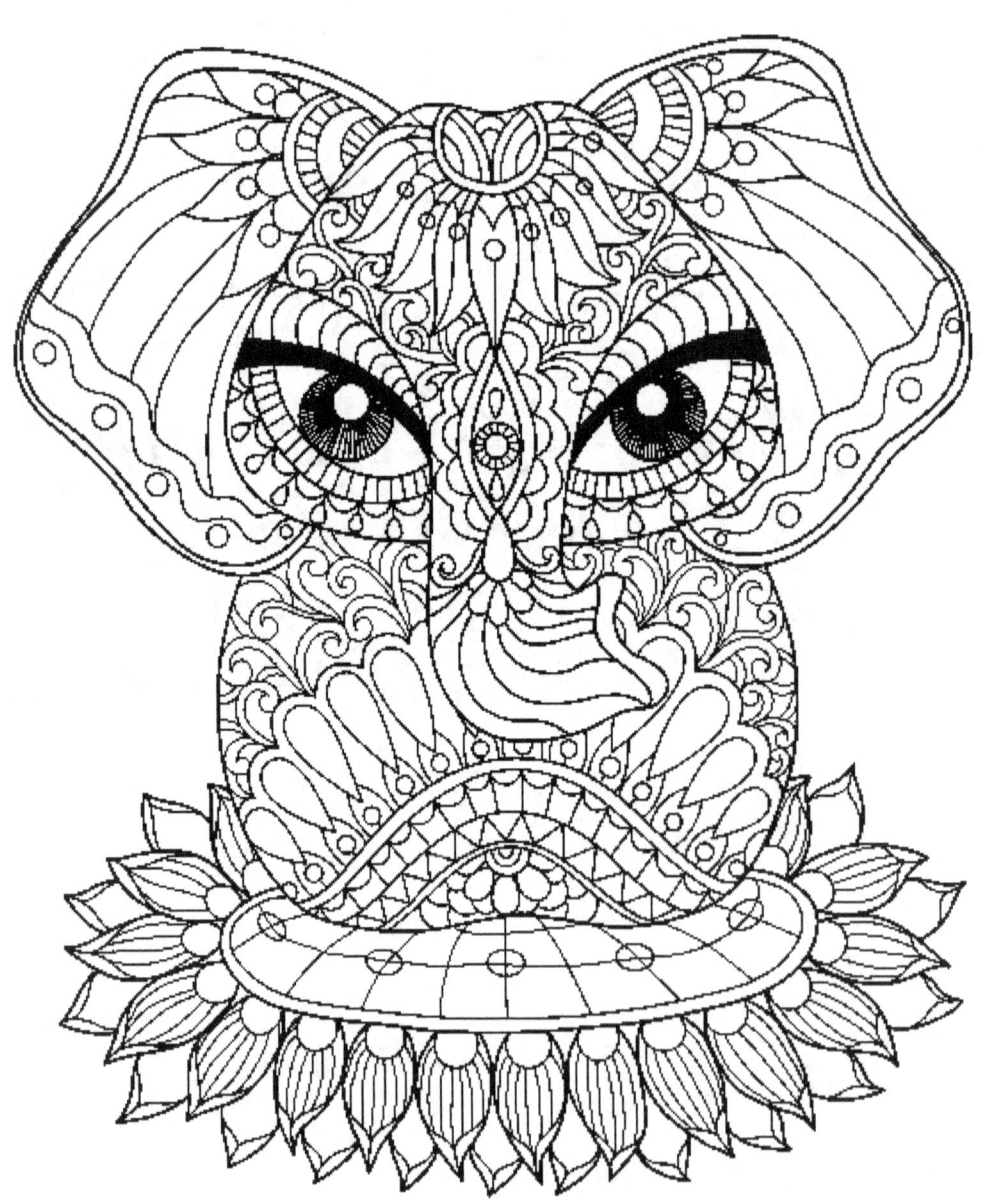

I'm not telling you it is going to be easy, I'm telling you it's going to be worth it.

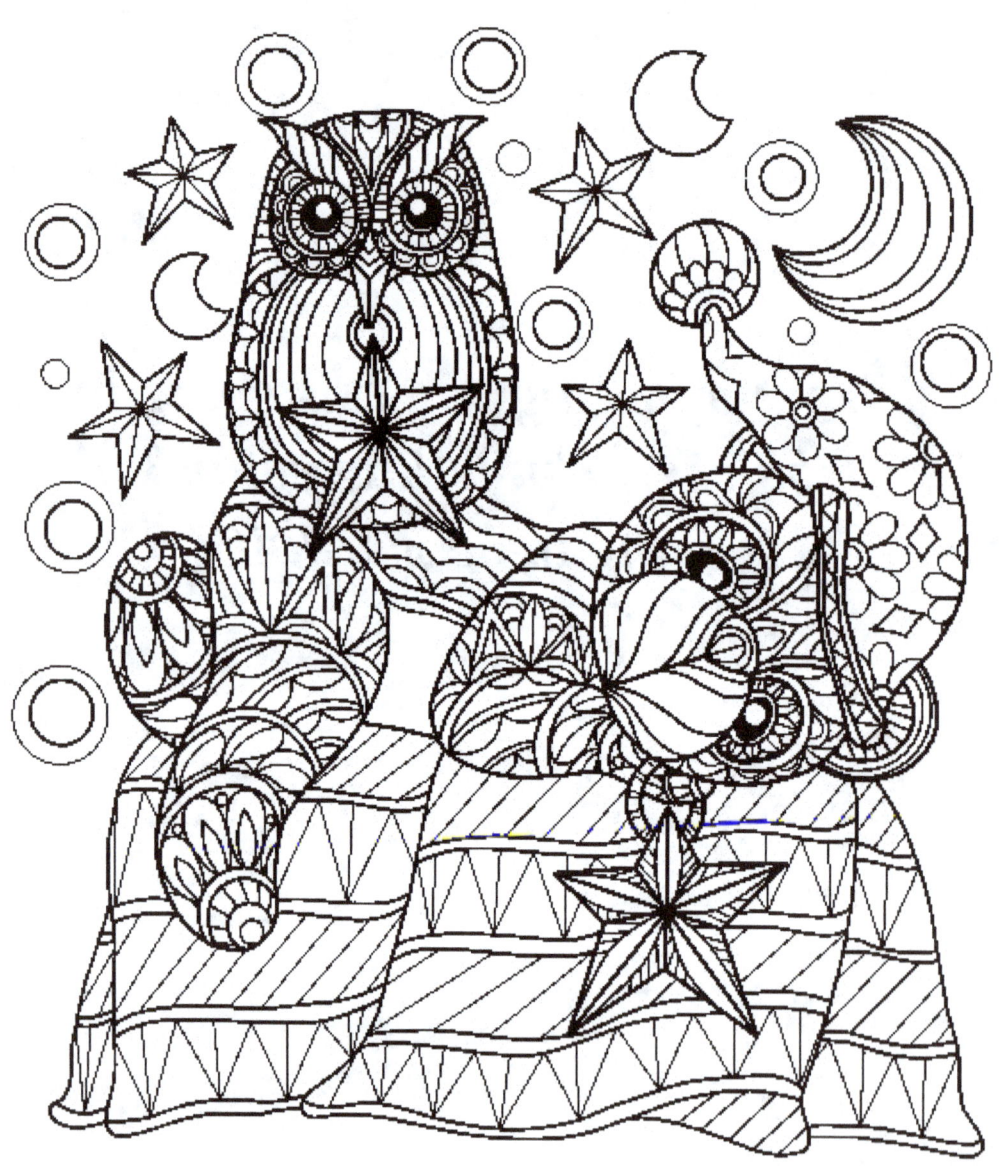

"Nothing is impossible; the word itself says, 'I'm possible!'"

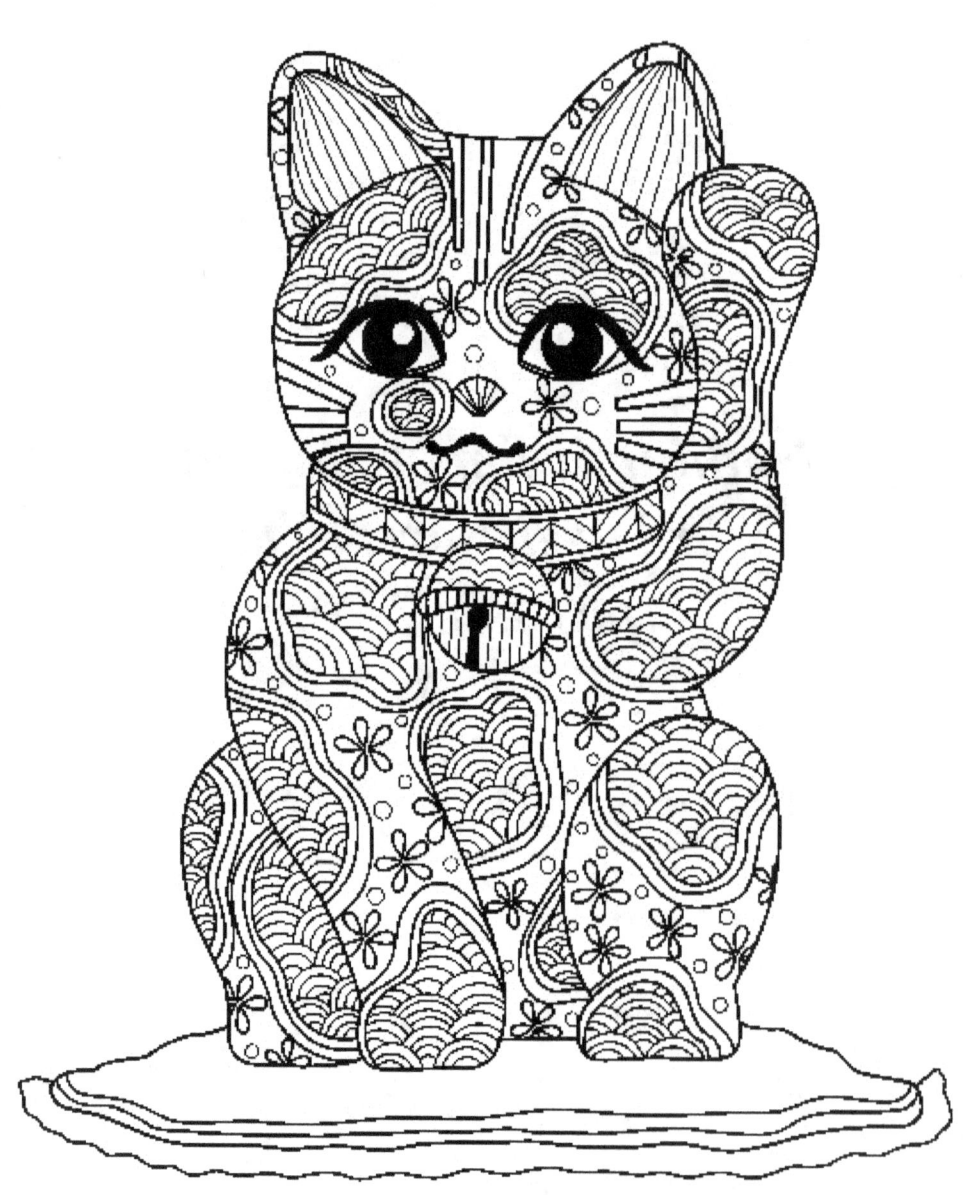

My recovery must come first so that everything I love in life doesn't have to come last.

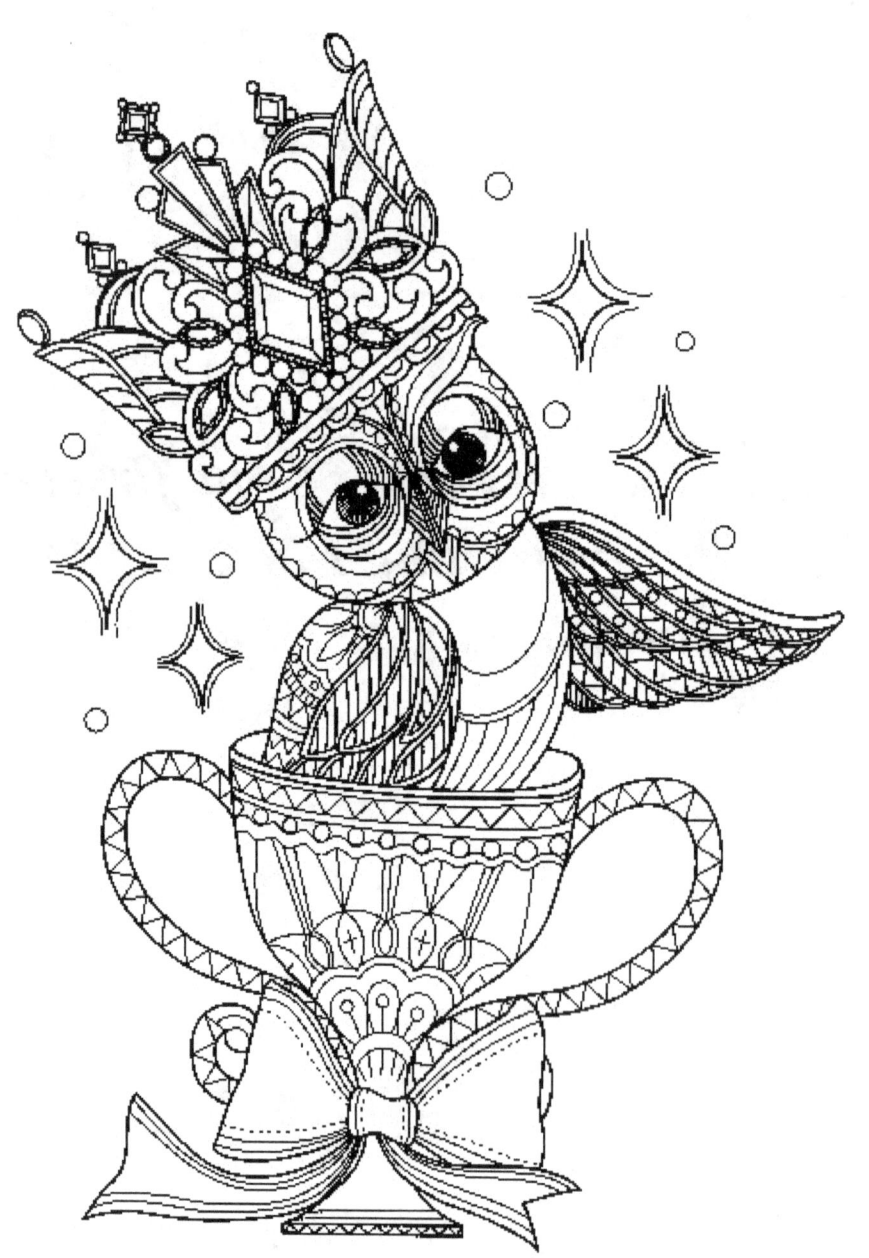

The goal isn't to be sober. The goal is to love yourself so much that you don't need to drink.

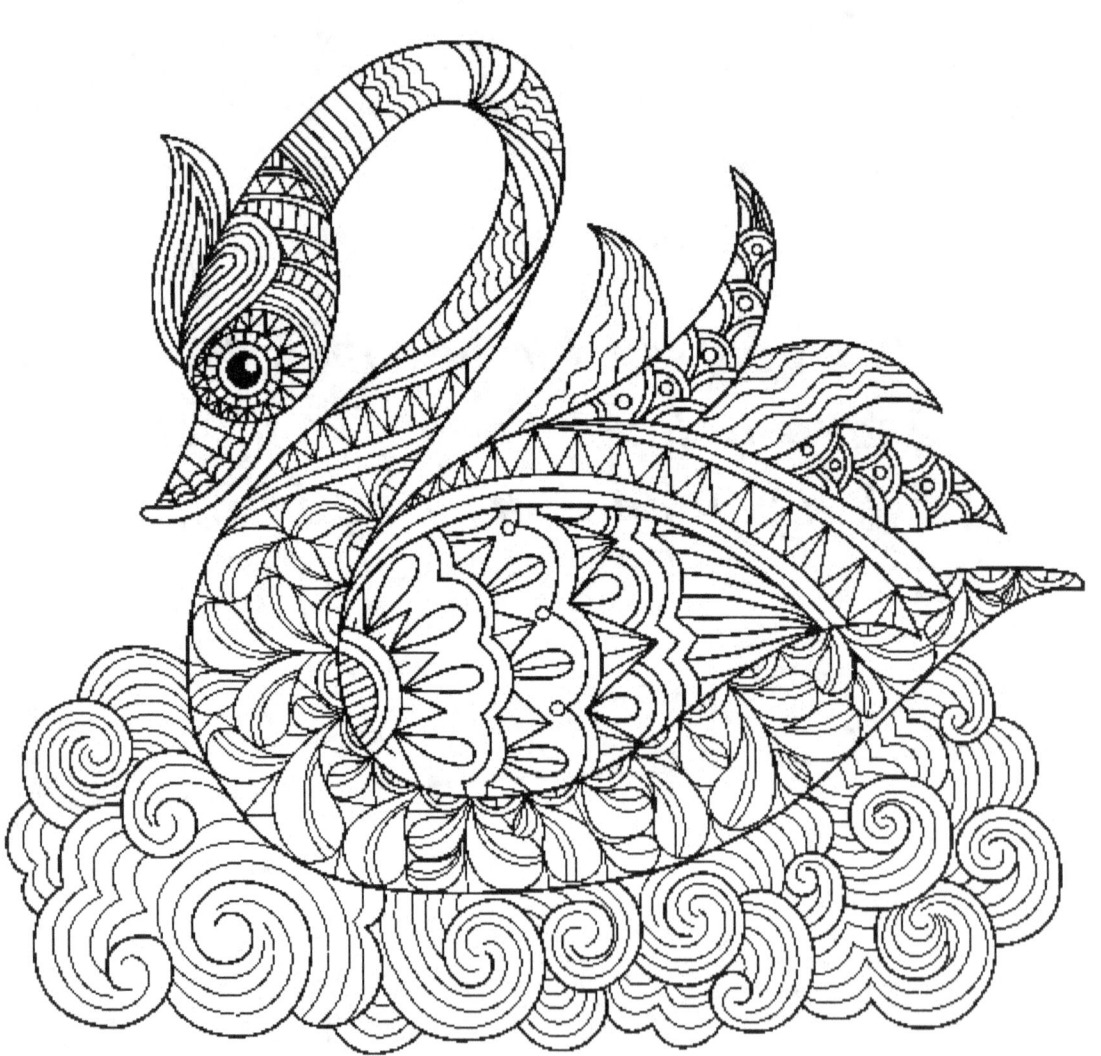

I understood myself only after I destroyed myself. And only in the process of fixing myself, did I know who I really was.

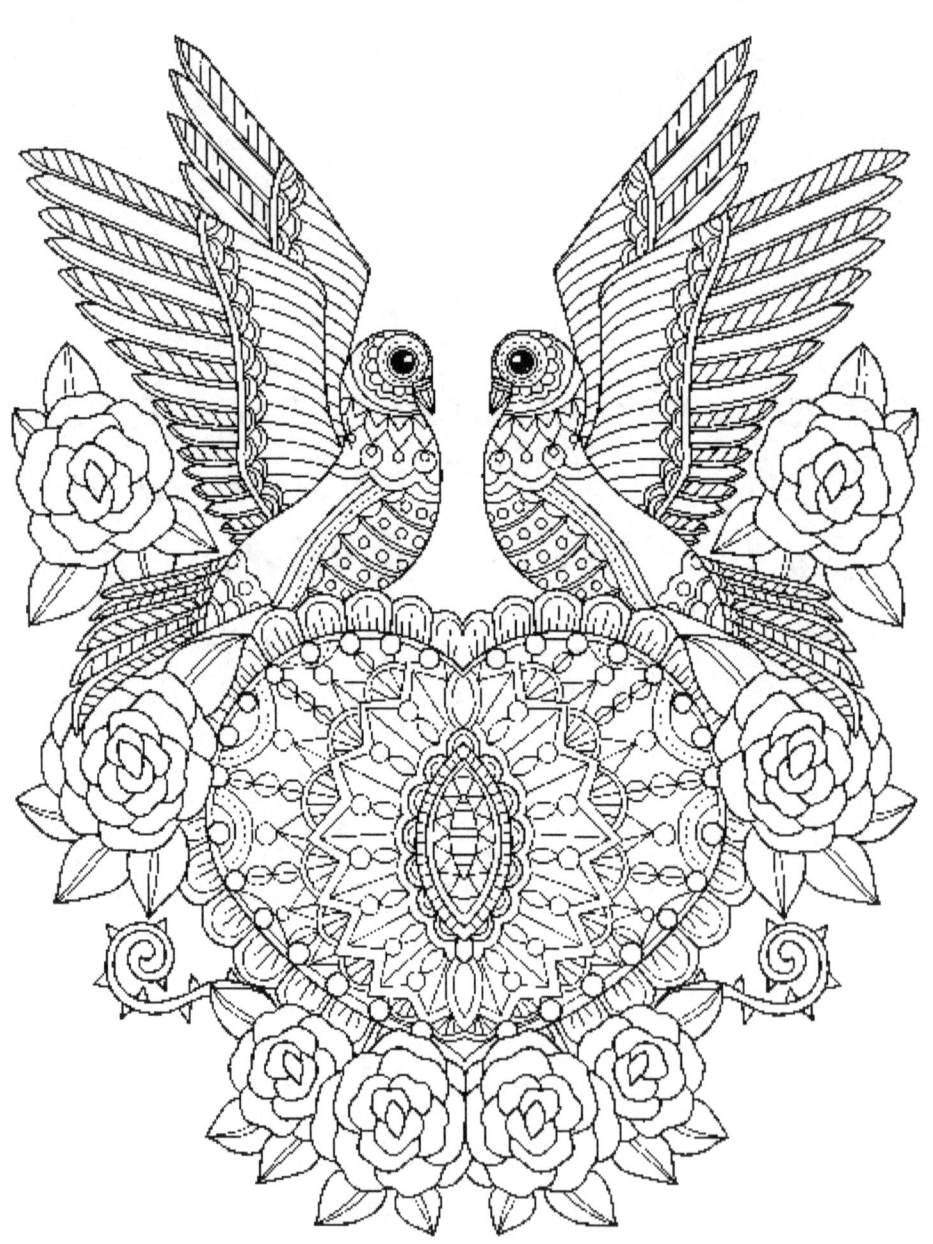

I am not defined by my relapses, but by my decision to remain in recovery despite them.

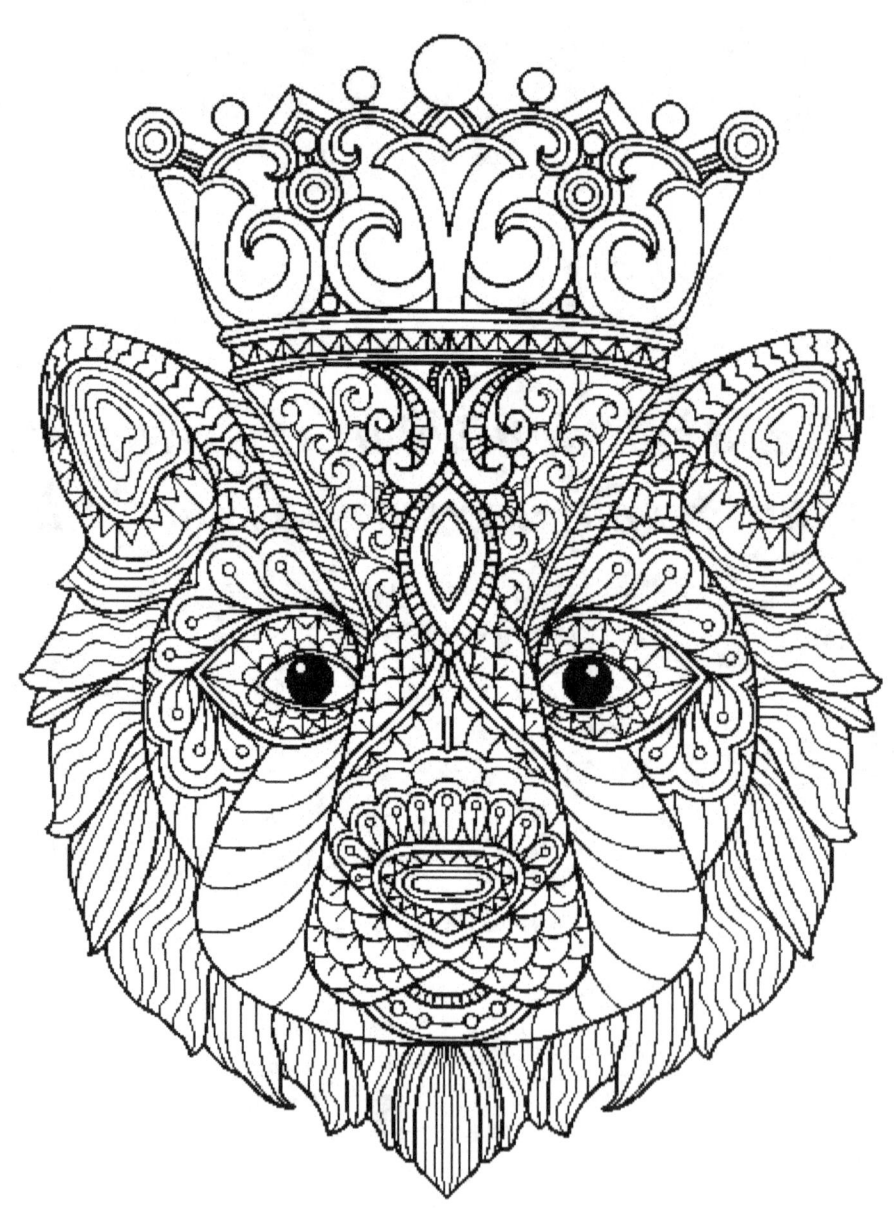

Recovery is an acceptance that your life is in shambles and you have to change.

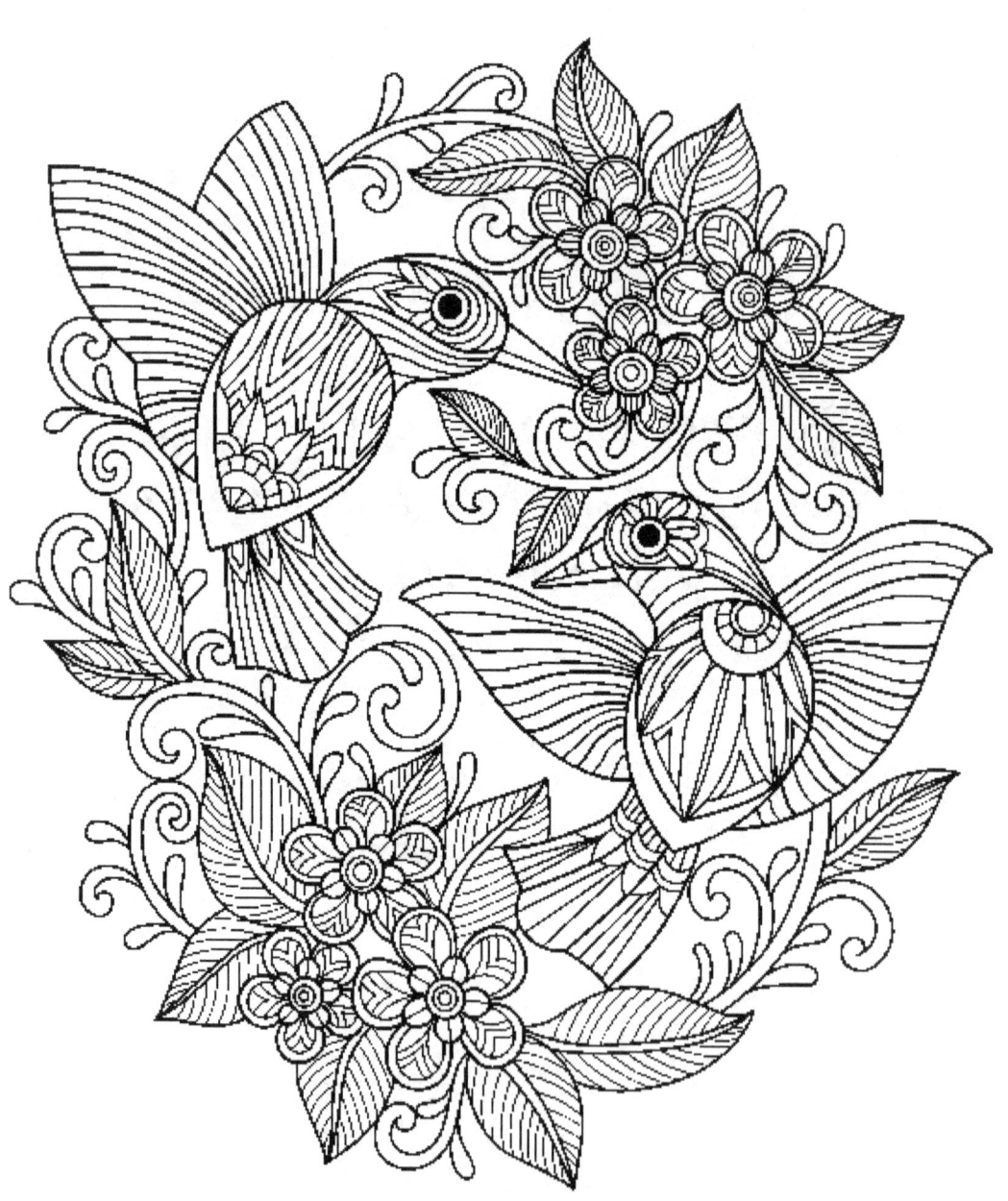

Recovery is about progression not perfection.

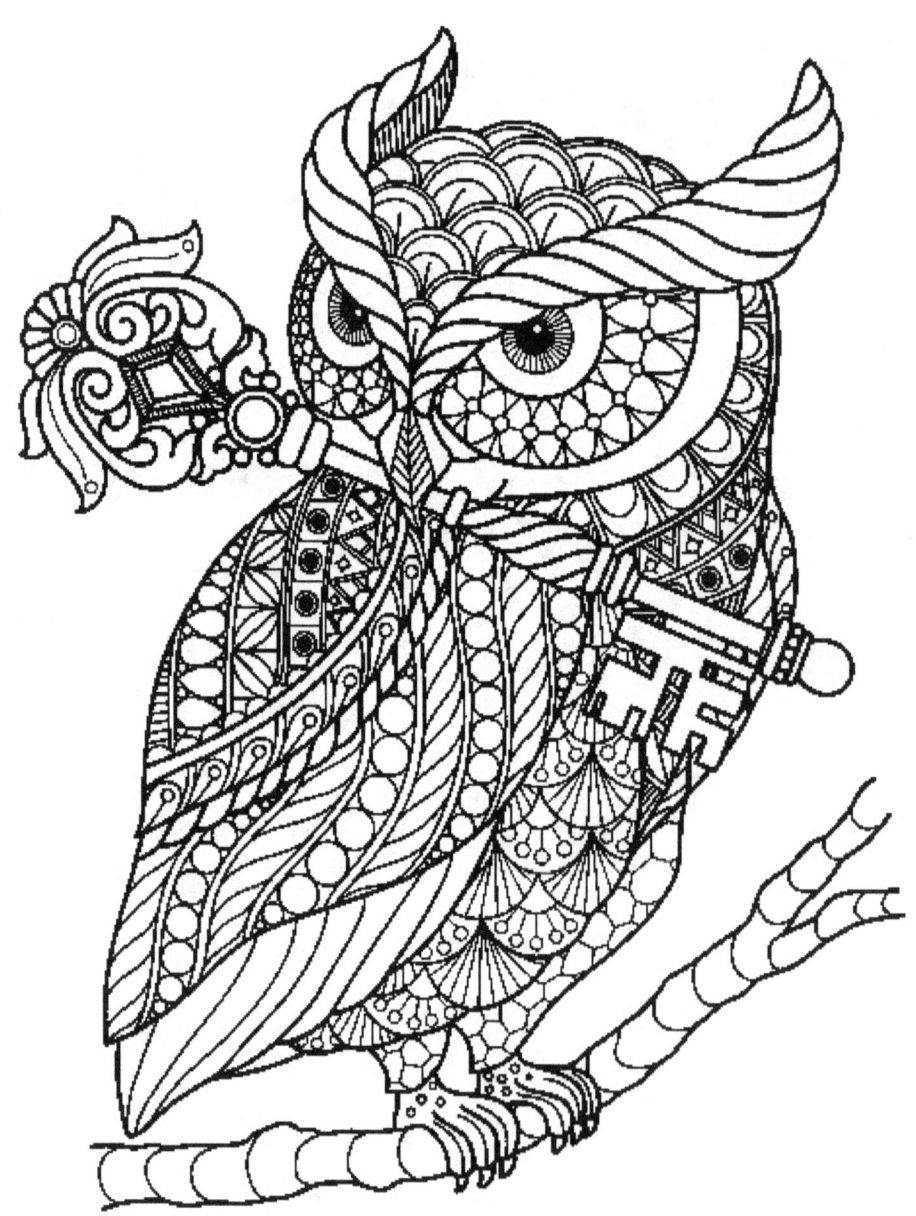

Recovery didn't open the gates of heaven and let me in. Recovery opened the gates of hell and let me out!

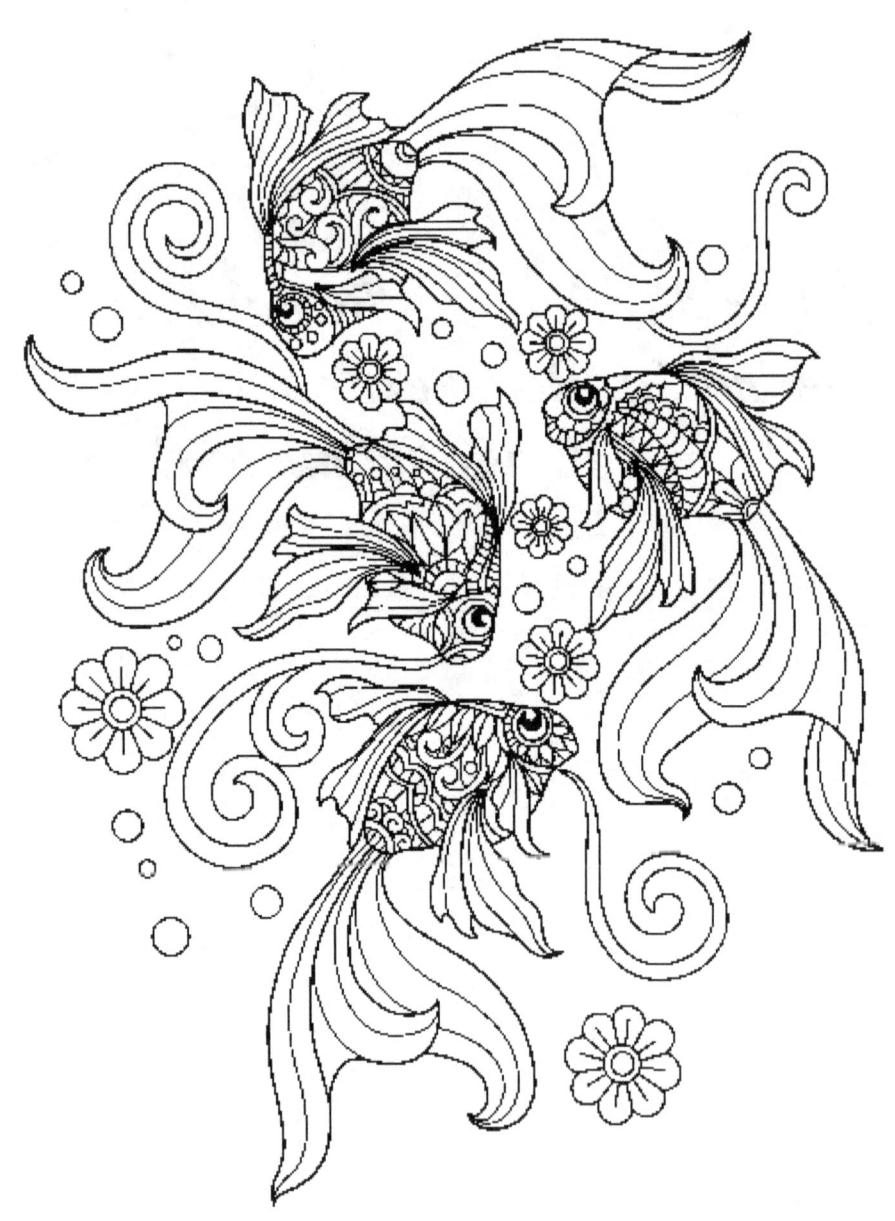

I know you're tired, I know you feel like giving up, but you're not going to. You know why? Because you are strong, and when you're survived through all the shit your addiction has but you through, you can survive recovery.

There is no shame in beginning again, for you get a chance to build bigger and better than before.

You don't get over an addiction by stopping using. You recovery by creating a new life where it's easier to not use. If you don't create a new life, then all the factors that brought you to your addiction will catch up with you gain.

If you find yourself in a hole, the first thing to do is stop digging.

Recovery is something that you have to work on every single day and it's something that doesn't get a day off.

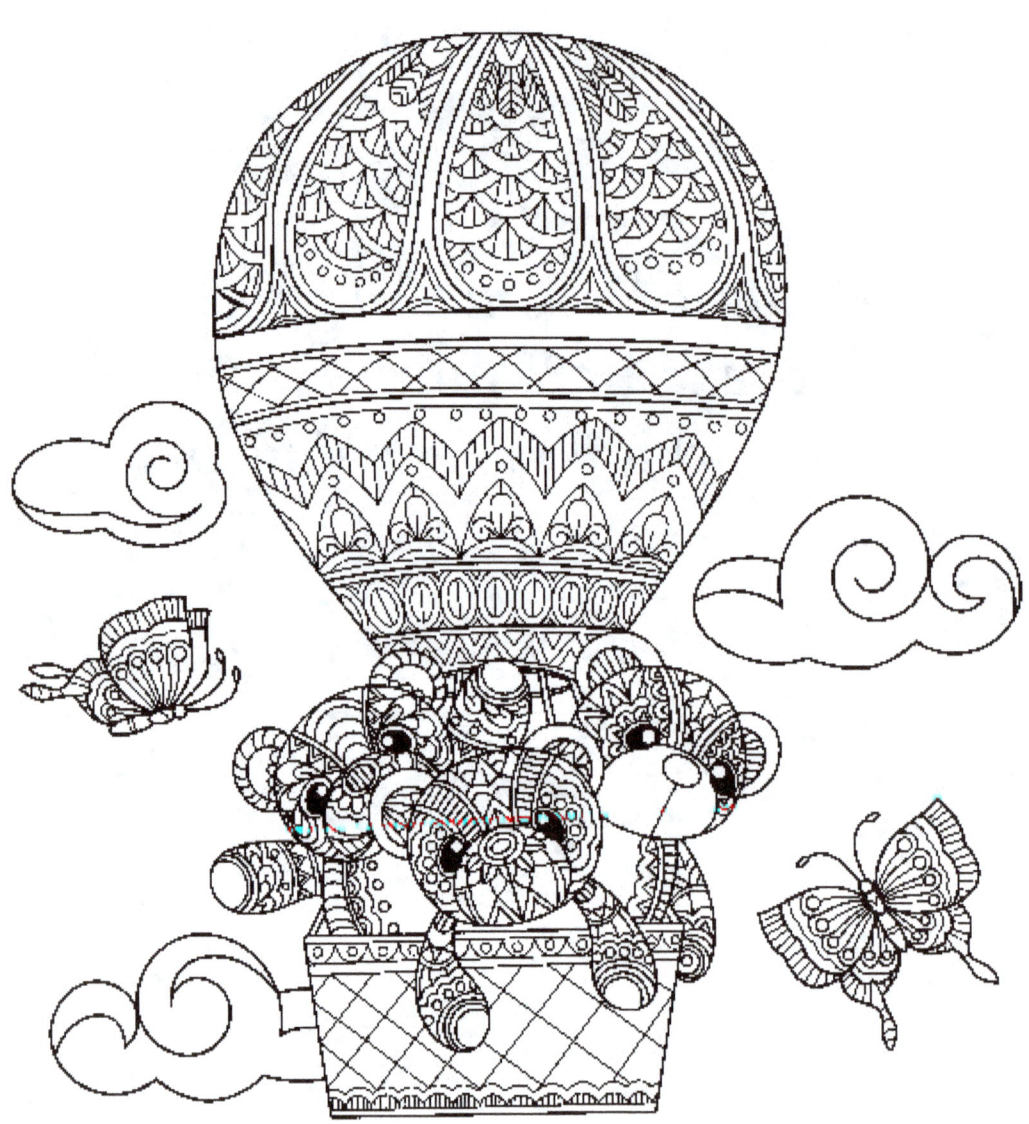

"Life doesn't get easier or more forgiving, we get stronger and more resilient."

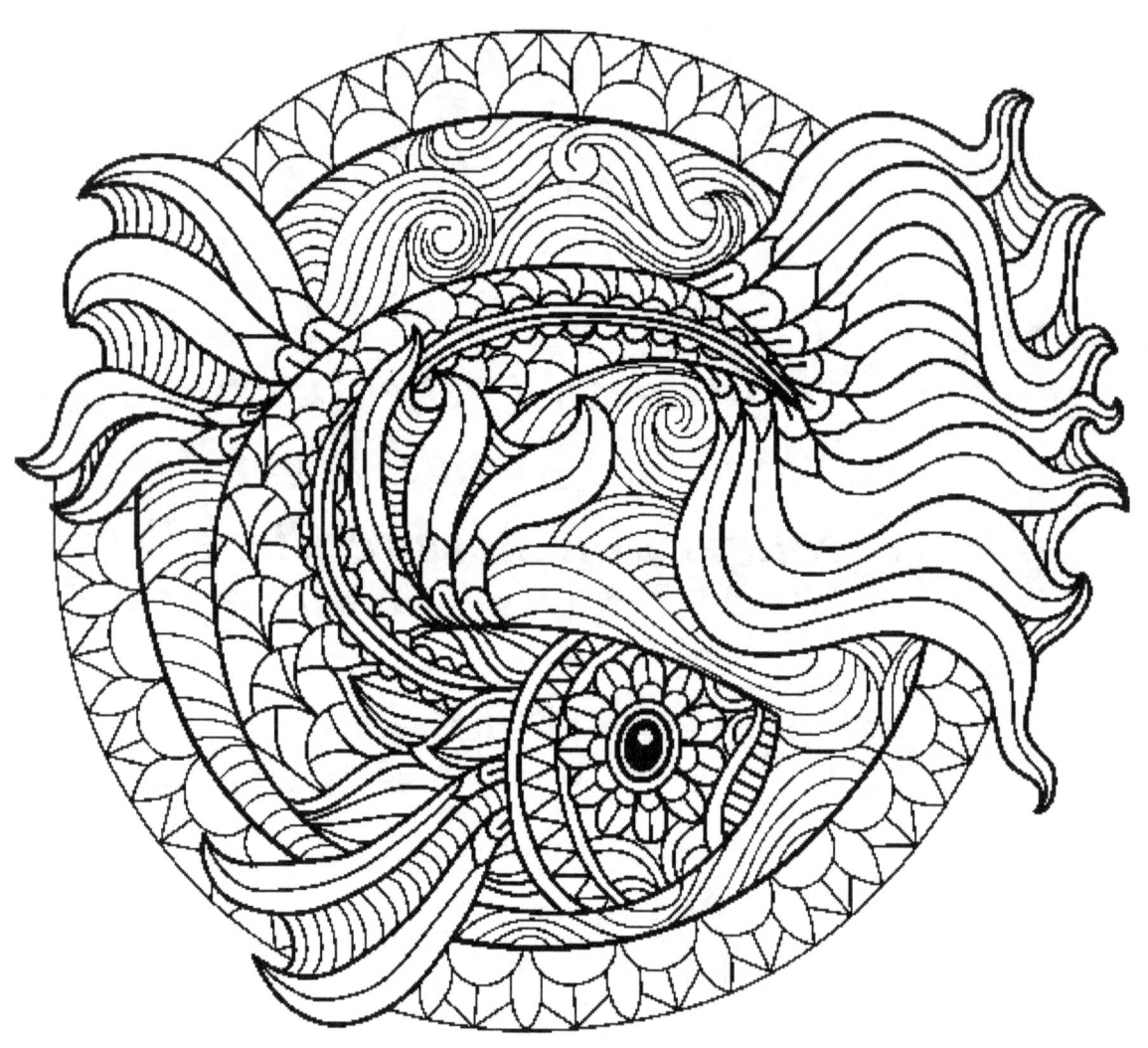

"Change must start from the individual. And the individual must want and feel ready to make such change."

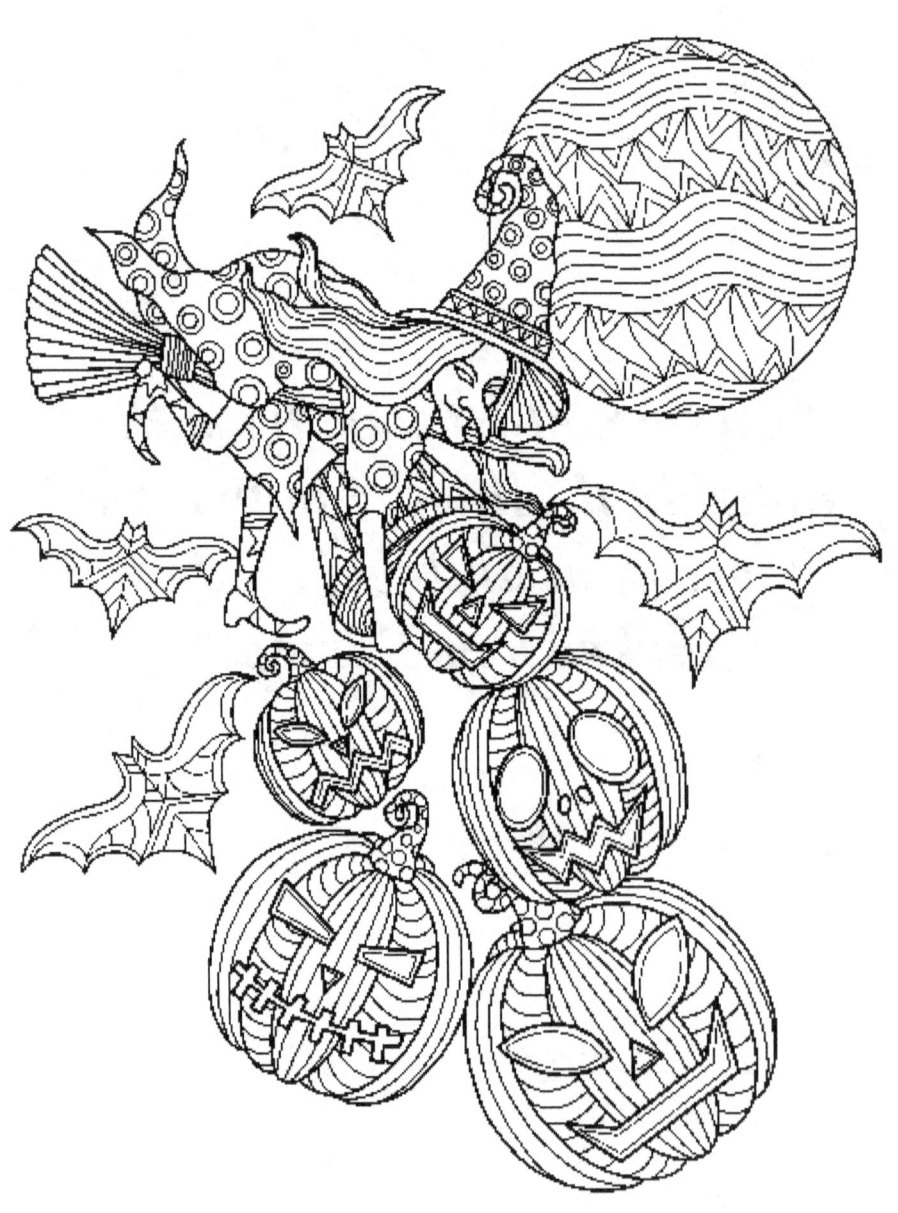

"Nothing is impossible; the word itself says, I'm possible!'"

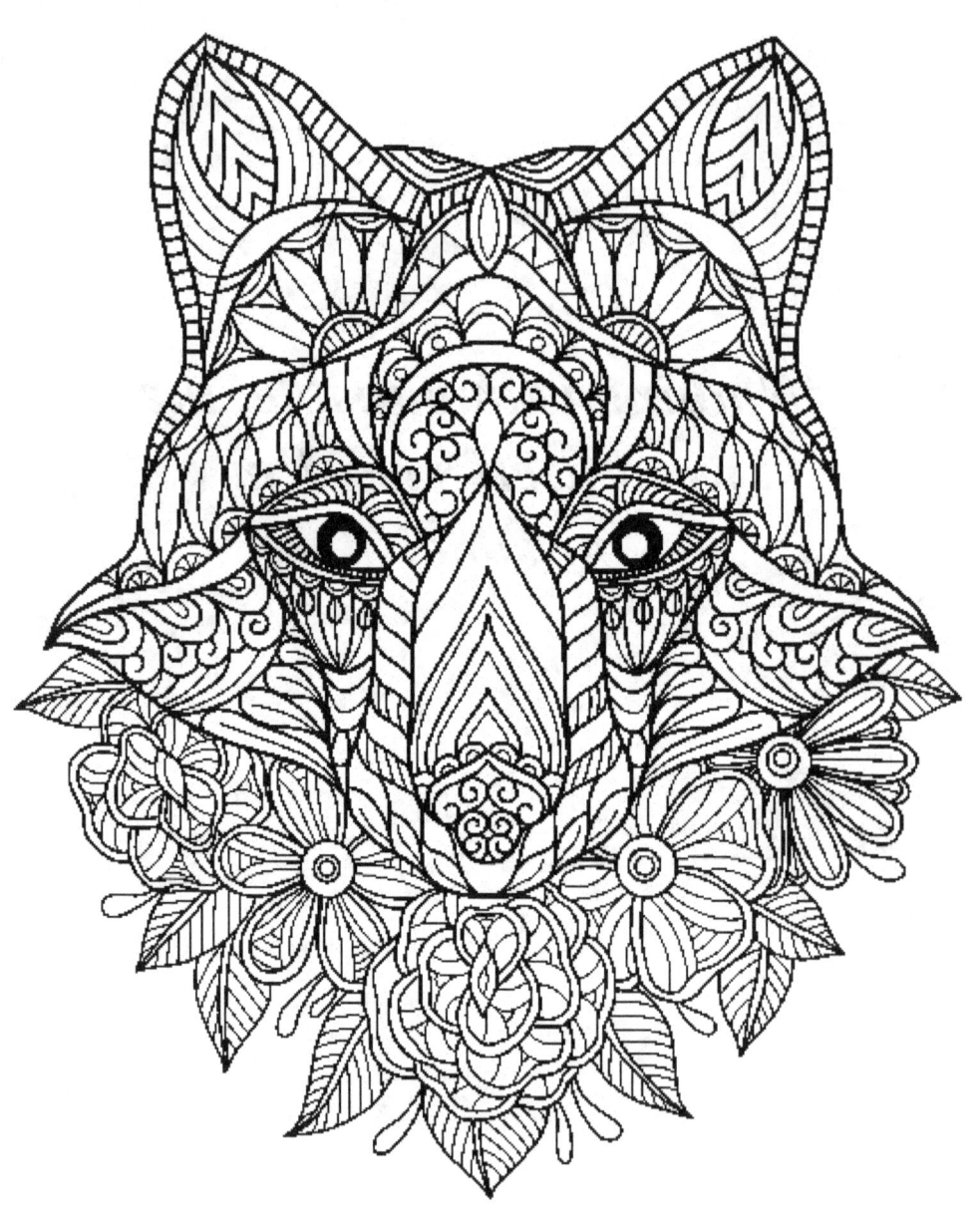

"If we are facing in the right direction, all we have to do is keep on walking."

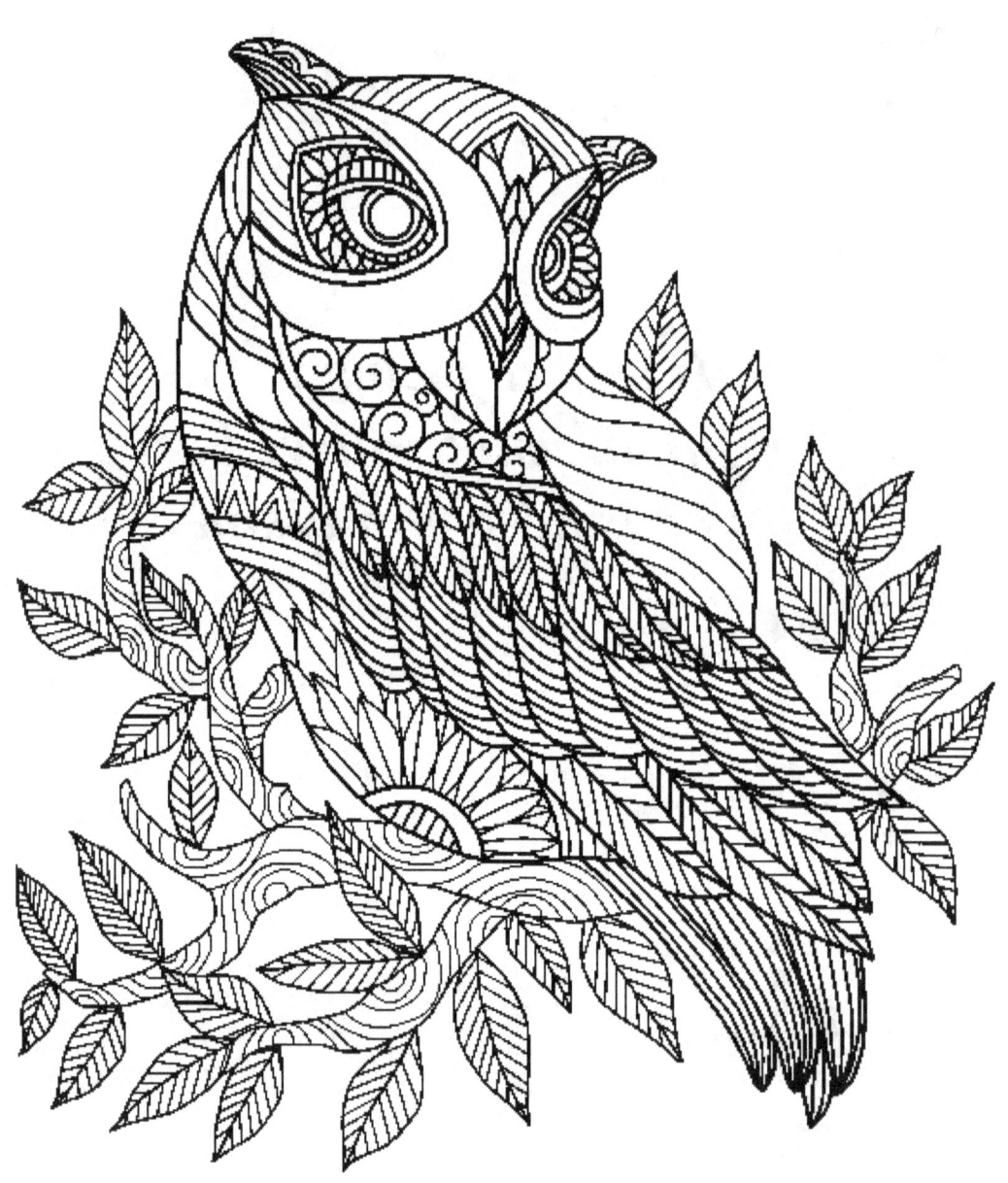

"If things go wrong, don't go with them."

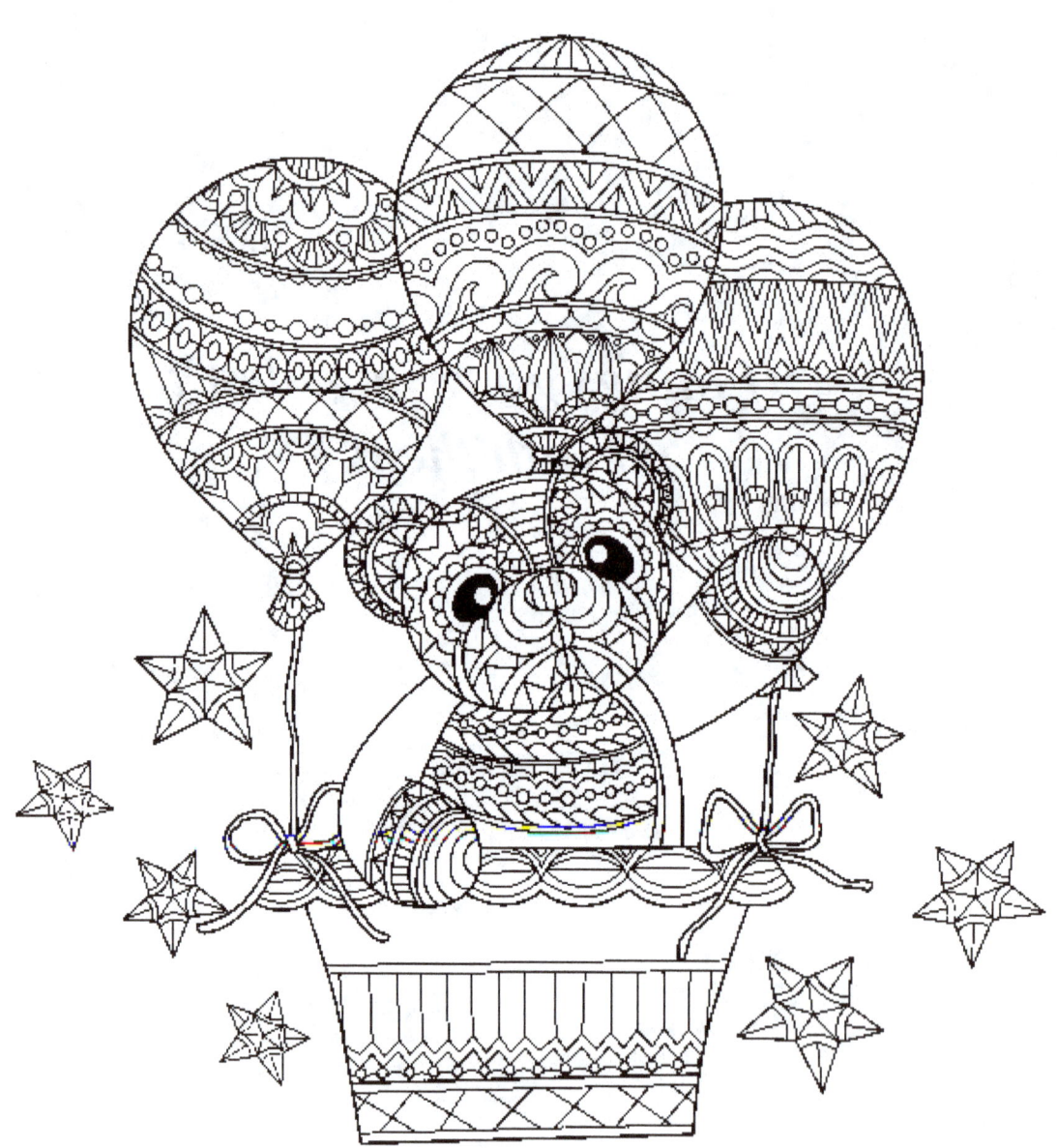

"Our greatest glory is not in never failing, but in rising up every time we fail."

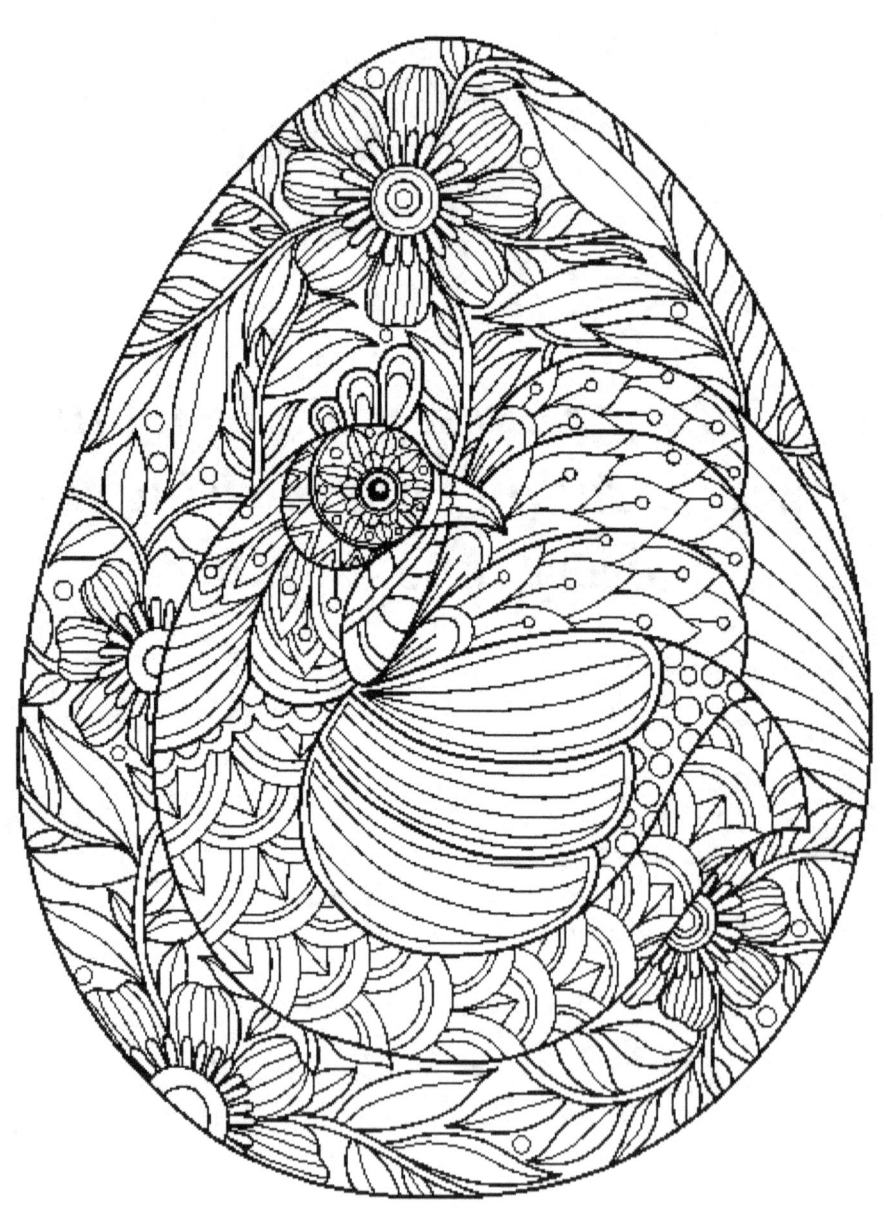

"I think that the power is the principle. The principle of moving forward, as though you have the confidence to move forward, eventually gives you confidence when you look back and see what you've done."

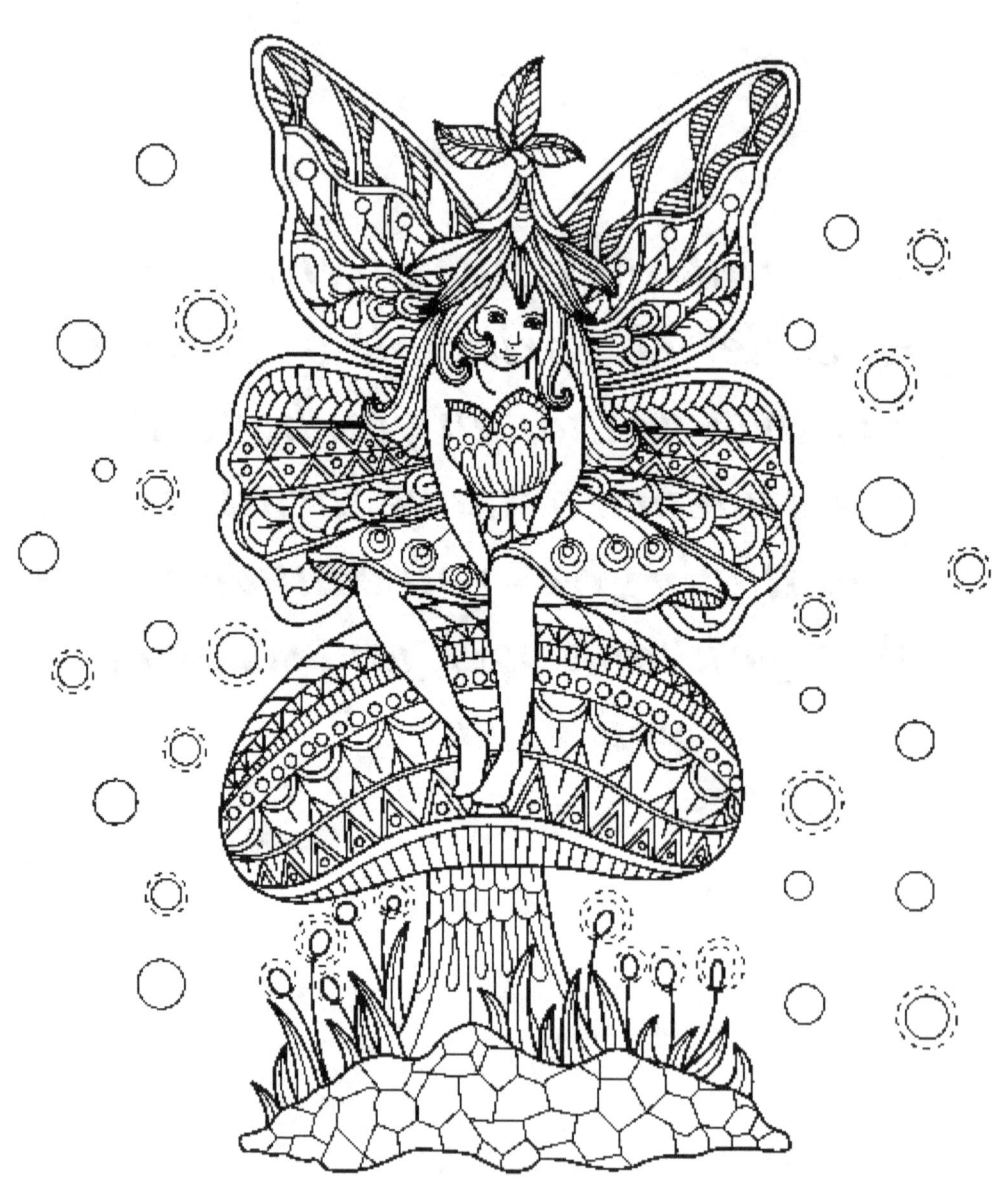

"In the end, some of your greatest pains become your greatest strengths."

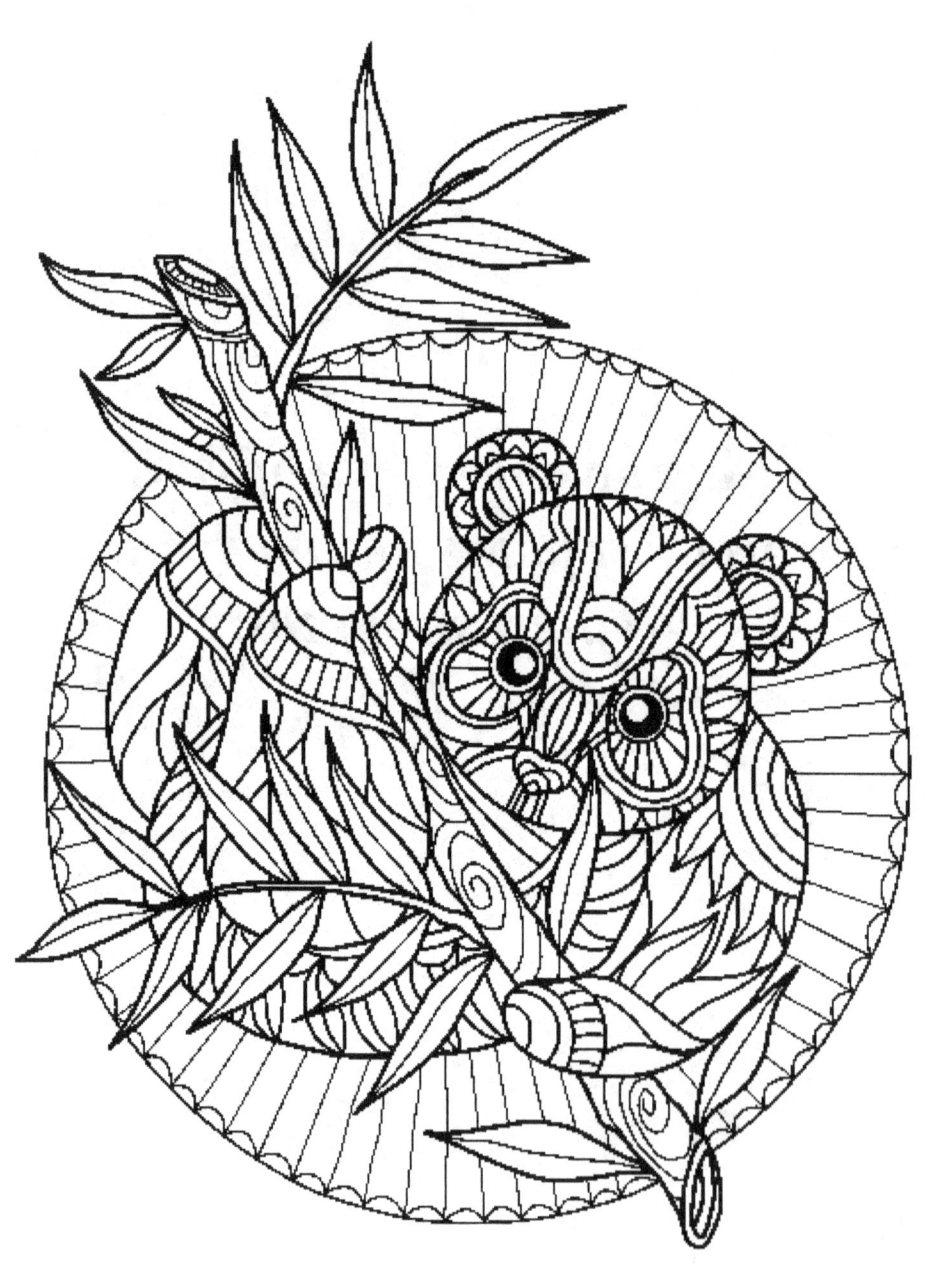

*"Listen to God with a broken heart.
He is not only the doctor who mends
it but also the father who wipes
away the tears."*

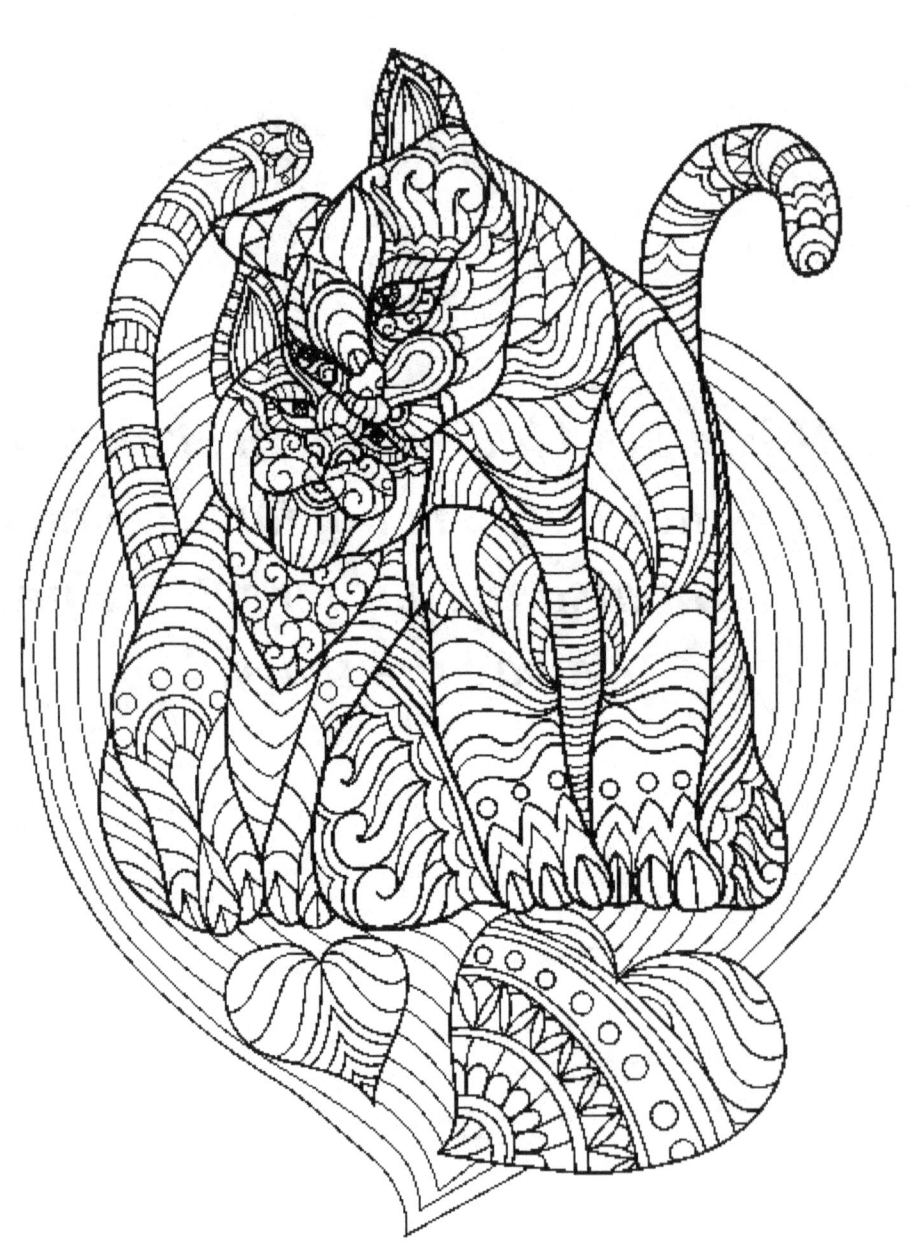

"Anyone can give up; it is the easiest thing in the world to do. But to hold it together when everyone would expect you to fall apart, now that is true strength."

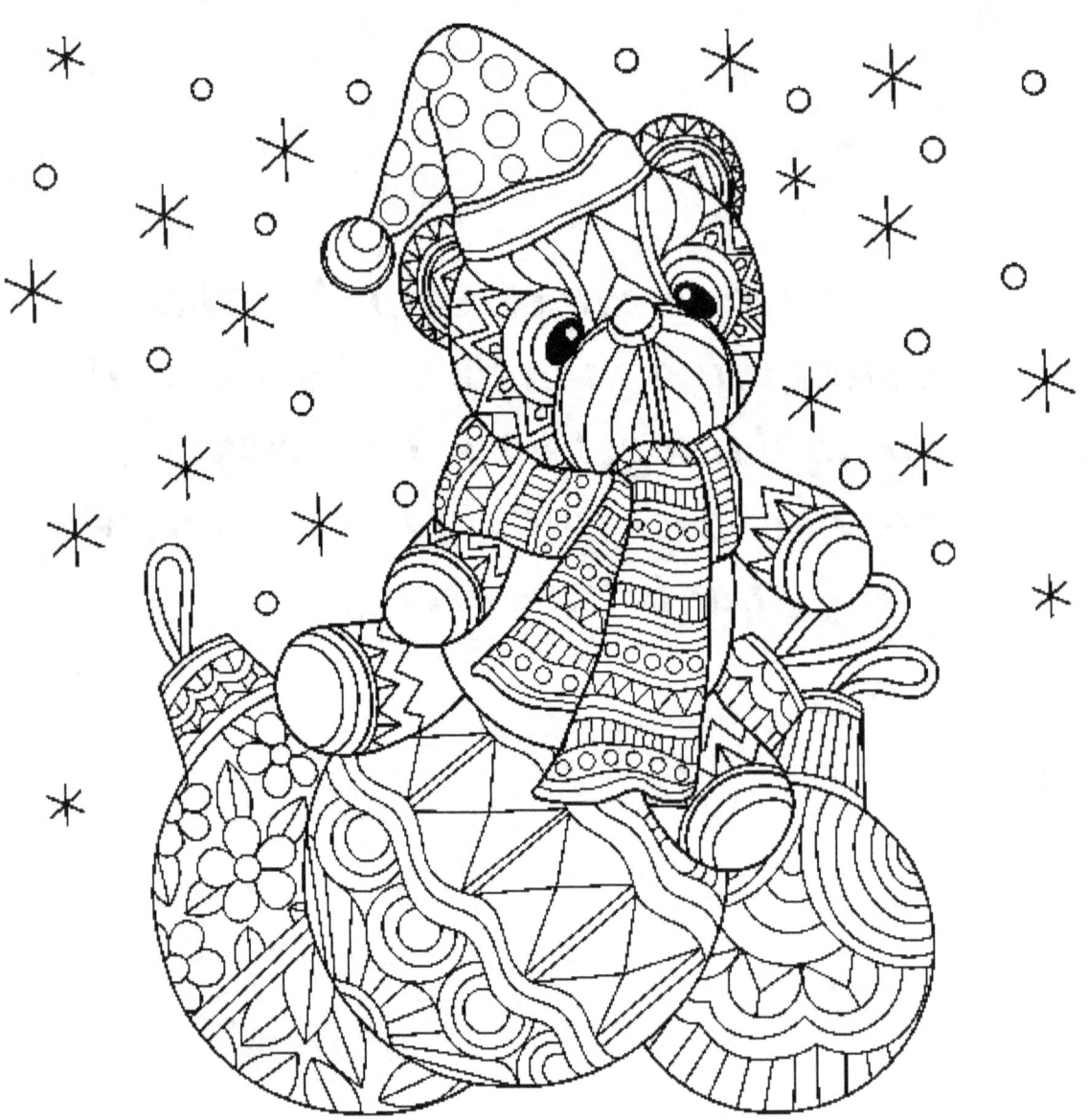

"Rising from the ashes, I am born again, powerful, exultant, majestic through all the pain."

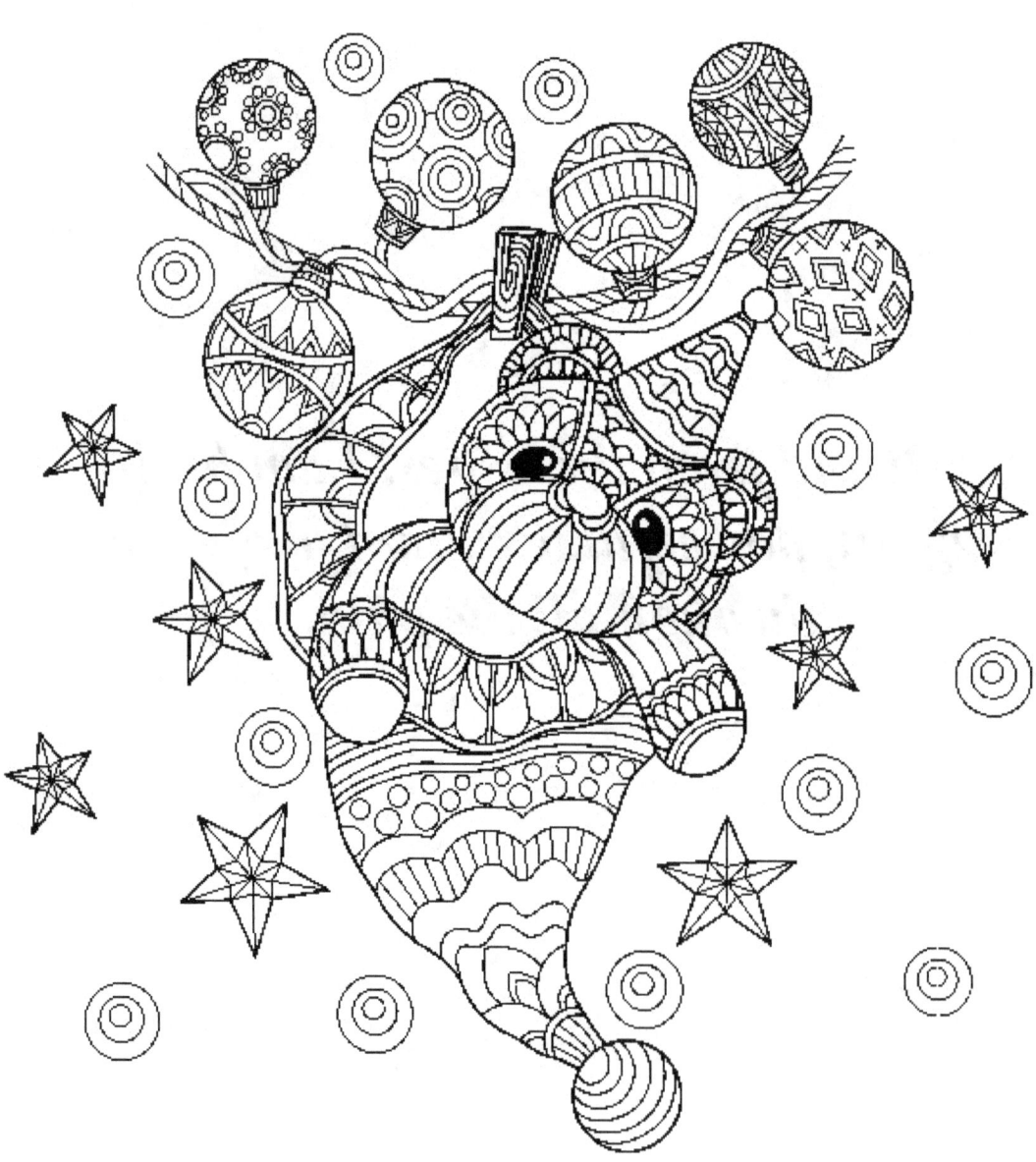

"You must do the things you think you cannot do."

www.ingramcontent.com/pod-product-compliance
Lightning Source LLC
Chambersburg PA
CBHW081658220526
45466CB00009B/2797